THE HOLLYWOOD PRINCESS

The Inspirational Ideas Behind the Elegant Life of Grace Kelly

STEVEN M. WAGNER

THE HOLLYWOOD PRINCESS

The Inspirational Ideas Behind the Elegant Life of Grace Kelly

Steven M. Wagner

All rights reserved. No part of this publication may be reproduced, distributed, or transmitted in any form or by any means, including photocopying, recording, or other electronic or mechanical methods, without the prior written permission of the publisher, except in the case of brief quotations embodied in critical reviews and certain other noncommercial uses permitted by copyright law.

Copyright © Steven M. Wagner, 2024

TABLE OF CONTENTS

PREFACE
INTRODUCTION
CHAPTER 1
The Early Life of Grace Kelly
The Lineage of Grace Kelly
Reminiscences and Impacts from Childhood
Effect of World War II's on Her Early Life
CHAPTER 2
Her Academic Career
Schooling in Elementary and High School
The Holy Child Academy and Subsequent Education
The Impact of Her Mentors and Teachers
CHAPTER 3
Grace Kelly's Marital Life
Falling in Love and Meeting Prince Rainier
The Royal Matrimony and Union
Motherhood and Raising Children in the Royal Family
CHAPTER 4
Rise to Stardom
Her Career in Early Modeling and Pioneering Role
The Academy Awards of 1955 and Princess Grace's Best Actress Nomination
Iconic Roles and Star Power
How Alfred Hitchcock Affected Her Career

Partnerships and Collaborations with Co-Stars
Grace Kelly's Role and the Impact of Technological Innovation on the Hollywood Industry
Grace Kelly's Impact on Fashion Trends
The Sad Demise: Car Accident and Legacy
Humanitarian Work and Philanthropy
Backing for Women's Empowerment and Education
Charity Activities in Monaco and Other Locations
Tradition of Giving Away
CHAPTER 6
Lessons Learned
Survival and Adaptability in the Face of Difficulties
Crucial Qualities: Genuineness, Lowliness, and Empathy
The Value of Self-Care, Community, and Family
CONCLUSION

PREFACE

I am filled with a sense of reverence and awe, when writing the biography of this great talented lady Grace Kelly. For decades, I have been fascinated by the captivating story of this extraordinary woman, who rose from humble beginnings to become a Hollywood icon, a princess, and a style legend. With her piercing blue eyes, raven hair, and effortless elegance, Grace Kelly seemed to embody the very essence of glamor and sophistication.

As I delved deeper into her life, I was struck by the depth and complexity of her character. Beyond the Hollywood red carpet and royal court appearances, I found a woman who was driven by a fierce intelligence, a quick wit, and an unwavering commitment to her passions. From her early days as a young actress struggling to make a name for herself in the competitive world of Hollywood, to her later years as a devoted mother and philanthropist, Grace Kelly's life was a testament to her resilience, determination, and generosity.

This biography is not just a chronicle of her remarkable life; it is also a tribute to the enduring power of her legacy. As we reflect on her remarkable journey from Philadelphia to Monaco, we are reminded of the

enduring allure of Hollywood's Golden Age, the timeless appeal of royal romance, and the inspiring story of a woman who transcended the boundaries of her time to leave an indelible mark on our collective imagination.

In the following pages, I invite you to join me on a journey into the life and times of Grace Kelly. From her early days as a small-town girl with big dreams, to her reign as Princess of Monaco and beyond, this biography is a celebration of her remarkable story – a story that will continue to captivate and inspire us for generations to come.

INTRODUCTION

"Welcome to the enchanted realm of Hollywood's Golden Age, where glamor and magic reign supreme! As you step into the enchanting world of Grace Kelly, get ready to be transported to a time of elegance, sophistication, and cinematic wonder.

Join me on a fascinating journey as we delve into the extraordinary life of one of Hollywood's most beloved and iconic stars, the incomparable Princess Grace Kelly. From her humble beginnings as a Pennsylvania girl with a passion for acting, to her rise to fame as a glamorous screen siren and ultimately, the beloved Princess of Monaco, this captivating tale is filled with secrets, surprises, and behind-the-scenes stories that will leave you spellbound.

Within these pages, you'll discover the untold stories of Grace Kelly's early struggles, her triumphs on the big screen, and her unforgettable romance with Prince Rainier. You'll be treated to intimate glimpses of her glamorous film sets, her friendships with Hollywood legends, and her personal struggles as a woman navigating the spotlight.

As you turn the pages of this captivating biography, you'll be immersed in the glamor and excitement of Old

Hollywood, where stars were born, and legends were made. Get ready to be swept away by the timeless charm and beauty of Princess Grace Kelly, an icon whose enduring legacy continues to inspire and captivate audiences to this day.

So sit back, relax, and indulge in the magical world of 'The Hollywood Princess: The Inspirational Ideas Behind the Elegant Life of Grace Kelly., and let yourself be transported to a time when movie magic was woven into the very fabric of our lives."

CHAPTER 1

The Early Life of Grace Kelly

The Lineage of Grace Kelly

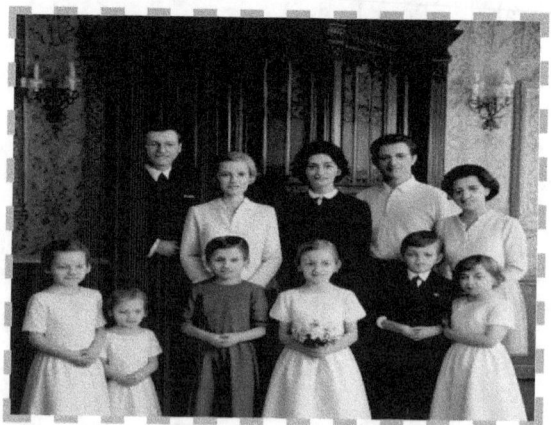

The Kelly's Lineage

Grace Kelly originated from the Kelly's family, who have a lengthy and intricate history spanning many centuries and countries. The family's Irish heritage began when their forebears left County Galway and immigrated to America in the 17th century. The first Kellys in American history are said to have moved to

Germantown, a hamlet in the Philadelphia region, where they were well-known members of the community.

John Kelly, Grace Kelly's direct ancestor, traveled from Ireland to Philadelphia in the middle of the eighteenth century. He was a young guy full of ambition who wanted to improve his family's quality of life as well as his own. John made his home in the quickly expanding Irish-American neighborhood of the city, where he ultimately opened his own company and worked as a merchant. He wed another Irish immigrant, Mary Anne Costello and the two of them produced eight children.
The Kelly family's strong feeling of community and family influenced their early years in Philadelphia. Families in Irish-American society were close-knit, often residing next to one another and depending on one another for assistance. The Kellys were no different; John was extremely well-known in the area's Irish-American society, and the family was actively engaged in social and political circles. Extended family members and friends often gathered for social gatherings and celebrations at the family's North 5th Street house, which was a center of activity.

The close-knit atmosphere Grace Kelly grew up in had a significant influence on her early life. Her huge extended family surrounded her and instilled strong values in her, such as hard work, loyalty, and community participation.

Her identity was also greatly influenced by her family's Irish history; she took great pride in her Irish ancestry and the customs that went along with it. The Kellys' everyday activities, such as neighborhood get-togethers and festivities and Sunday dinners at the family table, continuously emphasized the value of family and community.

Grace Kelly's life was still shaped by her family as she got older. Both of her parents, Margaret Majer Kelly and John Brendan Kelly, had a significant impact on her growth. Her father, a prosperous businessman and athlete, gave her a strong sense of drive and desire. Her mother instilled in her the values of love, compassion, and selflessness as a housewife and philanthropist. Grace's early upbringing was shaped in part by the strong feeling of community shown by the Kelly family; from an early age, she participated in local charities and social groups, setting the foundation for her future charitable pursuits.

The Philadelphia origins of the Kelly family also had a significant influence on Grace's life. Her options to pursue her hobbies and passions were infinite because of the city's rich history and thriving cultural environment. Grace was surrounded by culture and knowledge all the time, whether she was going to performances by the Philadelphia Orchestra or seeing the city's famous sites like Independence Hall. She was particularly struck by

the city's strong feeling of community; during her life, she often traveled back to Philadelphia to see friends and relatives. She was pleased to name Philadelphia her hometown.

In summary, Grace Kelly's early life was significantly shaped by her Kelly family heritage. She inherited strong qualities of diligence, commitment, and community service from her Irish-American ancestry. Her feeling of support and belonging was fostered by the close-knit Irish-American community in Philadelphia, and it persisted throughout her life. Grace's family continued to shape her as she got older, from her parents' strong morals to her participation in neighborhood nonprofits and social clubs. Grace's early childhood was greatly influenced by the Kelly family's Philadelphia background; she was always exposed to the culture, education, and community participation that would set the foundation for her success in the future.

Reminiscences and Impacts from Childhood

Grace Kelly at her Early age

Grace Kelly had a wonderful and impactful upbringing while growing up in Philadelphia, Pennsylvania. Born on November 12, 1929, Grace was the second of three children—the other two being her younger sister Elizabeth and elder brother John—to wealthy businessman John B. Kelly and erstwhile socialite Margaret Majer Kelly. Her parents, referred to as "Mr. and Mrs. Kelly," were a devoted and encouraging pair who taught their kids the importance of perseverance, generosity, and imagination.

Grace's mother Margaret Kelly, a former actress and model, had a major influence in developing her creative abilities at an early age. She supported her daughter's

participation in extracurricular arts, music, and ballet classes. Grace's imagination and creativity were stimulated by Margaret's wonderful paintings and sculptures, which were a reflection of her love of the arts. Grace was first exposed to the world of fashion by Margaret, who dressed her up and took her to exhibits and fashion events.

John B. Kelly, a self-made guy who started his own construction company from nothing, shared his daughter's enthusiasm. He often took her to the theater to see performances and school plays, encouraging her to follow her love for modeling and performing. Grace learned the value of endurance and hard work from John's business acumen, two traits that would help her succeed in her profession.

Grace's early years were greatly influenced by her loving and encouraging family. She gained a feeling of confidence and self-assurance that she would carry with her throughout her life thanks to her parents' support and direction. A unique feeling of warmth and togetherness in today's fast-paced world was developed in the Kelly family via music, laughing, and vibrant talks.

Grace used to read a lot as a youngster and would lose hours in the pages of great books. She especially enjoyed reading Jane Austen and the Brontë sisters' writings since they captured her imagination and served as

inspiration for her writing. Her cultural preferences were also greatly influenced by her parents' passion for classical music. They often took her to operas and concerts, introducing her to the world of classical music at a young age.

Grace Kelly's early years were marked by a distinctive fusion of contemporary elements and traditional beliefs. She was able to pursue her artistic abilities without worrying about rejection or failure because of her parents' support and direction. In the Kelly home, one may find a nurturing environment for creativity, dreams, and rewards for perseverance. Grace Kelly's eventual success as a Hollywood actress, fashion star, and loving mother was made possible by her perfect upbringing.

Effect of World War II's on Her Early Life

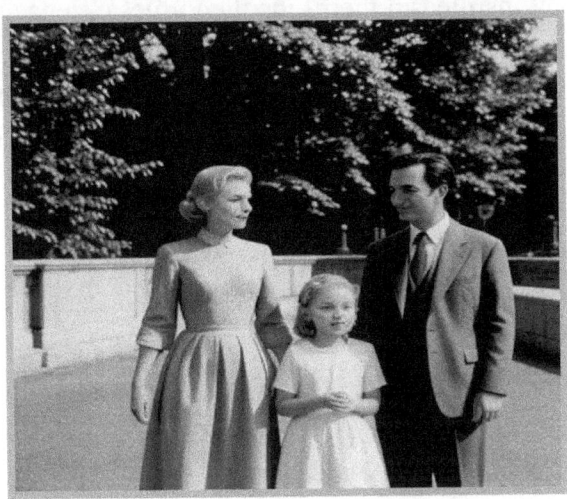

Grace Kelly and her parents in Philadelphia Pennsylvania

The city of Philadelphia, Pennsylvania, had a major influence on Grace Kelly's attitude and outlook on life. Her ideals and goals were greatly influenced by the city's rich cultural legacy, historic sites, and vibrant feeling of community. Grace was greatly impacted by her parents, Margaret and John B. Kelly, who raised her as the second of three children and taught her the value of perseverance, hard effort, and artistic expression.

For a young girl who loved the arts, Philadelphia's multicultural vibe, thriving arts scene, and plenty of cultural institutions offered an engaging setting. Grace's parents, who came from modest backgrounds

themselves, had fought hard to achieve success in life, and they instilled in their kids the virtues of tenacity and independence. Grace gained a strong feeling of camaraderie and empathy from her upbringing in this city of brotherly love, traits that would benefit her throughout her life.

Grace was greatly influenced by the Kelly family. From an early age, her parents supported her in pursuing her artistic abilities by enrolling her in music and ballet programs. Margaret Kelly, a former actress and model, had a crucial role in encouraging Grace's artistic expression. She introduced her to the world of art and design by taking her to the theater, exhibits, and fashion events regularly. Grace became interested in the fashion business because Margaret clothed her daughter in fashionable attire, which demonstrated her love of beauty and fashion.

John B. Kelly was a prosperous businessman and entrepreneur who taught his kids the value of perseverance and hard work. He would often take them to his building projects, where they would see him put forth endless effort to create something new. Grace learned the value of hard effort and the significance of seeing projects through to completion from this practical approach to business. John had a strong effect on his daughters' education as well, encouraging them to devote themselves wholeheartedly to their academic pursuits.

The Kelly family house was a hive of artistic activity, with laughing, music, and animated discussions permeating the space. Grace's parents encouraged each kid to pursue their gifts and interests while fostering a feeling of togetherness within the family. Grace felt free to pursue her interests in this encouraging atmosphere without worrying about rejection or failure.

The lengthy history of Philadelphia also had a big influence on Grace's perspective. She developed a strong feeling of patriotism and pride in her country as a result of growing up close to Independence Hall, the site of the signing of the US Constitution and the Declaration of Independence. Numerous galleries, museums, and other cultural organizations in the city offered countless chances for education and cultural enrichment.

For Grace Kelly, growing up in Philadelphia was a formative experience in many ways. Her ideals and aspirations were formed by the city's distinctive fusion of history, culture, and community, which equipped her for a career as a Hollywood actress and style icon. Her parents' impact on her life was crucial in fostering her artistic abilities and imparting in her the work ethic and perseverance that would benefit her much in her professional life.

CHAPTER 2

Her Academic Career

Schooling in Elementary and High School

Grace Kelly while studying in Ravenhill Academy

Grace Kelly's early academic experiences, linguistic development, and artistic inclination were greatly influenced by her elementary and high school education.

She attended public schools in Philadelphia, Pennsylvania, where she was exposed to a well-rounded curriculum that encouraged her creativity and curiosity as a child.
She started attending Ravenhill Academy, a prestigious Catholic school in Philadelphia when she was five years old. Her early school years were characterized by her curiosity about the outside world and her passion for learning. She enjoyed her language arts lessons, which gave her a solid foundation in reading, writing, and grammar. Her professors, Mrs. Elizabeth Collins and Mrs. Agnes Murphy pushed her to use writing and storytelling as creative outlets.

Grace's passion for the arts blossomed as she advanced to the higher elementary school years. She took music lessons, where she picked up the piano and fell in love with classical music. Mrs. Margaret Kennedy, her music instructor, encouraged her to follow her love for music after recognizing her aptitude.
She finished her high school career at the esteemed private Stevens School in Philadelphia after transferring there in the eighth grade. The demanding curriculum at Stevens School pushed her intellectually and gave her chances to improve her language abilities. Her favorite topics were history, French, and English since she thought them to be interesting and fun.

Grace had the good fortune to have several very effective professors at Stevens School who greatly influenced the way she experienced her academic career. Mrs. Anna B. Smith, her English instructor, encouraged her to pursue creative writing after recognizing her extraordinary writing abilities. Grace's linguistic abilities improved under Mrs. Smith's tutelage, and these abilities would benefit her throughout her career as an actor and style icon.

She was involved in the school's theatrical club and chorus in addition to her academic endeavors. She participated in several school projects, such as plays and musicals, which helped her gain stage confidence and acting abilities.

Grace's study in French language and literature in high school helped her to further improve her language abilities. She was first exposed to French literature via the writings of Victor Hugo and Gustave Flaubert, which she loved.

To sum up, Grace Kelly's education from elementary school through high school paved the way for her career as an actress, style icon, and loving mother. Her passion for education, proficiency in language, and interest in the arts were fostered by committed educators who supported her artistic endeavors and intellectual aspirations. Her early experiences gave her a strong

sense of self-assurance, perseverance, and hard work that would benefit her throughout her life.

The Holy Child Academy and Subsequent Education

Grace Kelly while studying in Catholic girls' school in Rye, New York

A Catholic girls' school in Rye, New York called the Academy of the Holy Child had a big influence on Grace Kelly's upbringing and her career. Grace attended the Academy from 1943 to 1947, where she was exposed to a demanding academic program with a focus on the arts. Grace performed in many shows and was an active member of the theater club at the Academy of the Holy

Child. Shakespeare's plays in particular drew her in and ignited her love of theater and performance. Her participation in the school's plays helped her hone her improvisation, scene analysis, and character creation abilities in addition to giving her more self-assurance on stage.

She played the title part in the school's production of James M. Barrie's play "The Little Minister," which was one of her most prominent performances at the time. Teachers and classmates praised her for her portrayal of the vivacious and self-reliant young lady, Chrissie. Her acting abilities were refined by this experience, which also gave her a greater feeling of confidence and self-assurance.

Grace not only had a passion for theater, but she excelled academically as well. She did very well at school, especially in literature, history, and languages. Her remarkable linguistic talents were acknowledged by her Academy professors, who also encouraged her to further her love for French literature.

While attending the Academy of the Holy Child, Grace also became interested in beauty and fashion. She participated actively in the school's fashion club, where she gained knowledge in cosmetics, styling, and fashion design. Her passion for beauty and fashion would subsequently come to define her career as a style icon.

Grace pursued her love of acting and theater at the renowned Stevens School in Philadelphia after her 1947 graduation from the Academy of the Holy Child. She studied drama at the American Academy of Dramatic Arts in New York City after realizing that her time at the Academy had equipped her for more difficult parts in theater and film.

Grace studied acting at the American Academy of Dramatic Arts, where she was tutored by well-known teachers. She was introduced to a range of approaches and strategies, including those created by Konstantin Stanislavski and Lee Strasberg. She gained a solid foundation in acting techniques from her studies at the school, which benefited her throughout her career.

As an actor, Grace Kelly's time at the Academy of the Holy Child was crucial to her growth. She was able to advance as a performer because the school concentrated on the arts as well as her innate skill and love of theater. The abilities and self-assurance she acquired during this period formed the basis for her subsequent achievements as a Hollywood actor and style icon.

The Impact of Her Mentors and Teachers

Grace Kelly and her teachers Konstantin Stanislavski and Lee Strasberg

Grace Kelly's intellectual and creative growth was greatly influenced by the mentors and professors who guided her. She had the chance to collaborate with several influential people throughout her schooling, who not only gave her useful skills but also inspired confidence and aspiration in her.

Grace was lucky to have several very important instructors at the Academy of the Holy Child, where she studied from 1943 to 1947, who saw her extraordinary skill and promise. Her English teacher, Mrs. Anna B. Smith, was one such instructor who pushed her to pursue creative writing after recognizing her remarkable writing abilities. Grace's linguistic abilities improved under Mrs.

Smith's tutelage, and these abilities would benefit her throughout her career as an actor and style icon.

Sister Mary Francis, a theater and music instructor at the Academy, was another significant educator. Grace had a natural gift for acting, which Sister Mary Francis encouraged her to develop. Grace was given the chance to perform on stage by her, which helped her gain stage presence and confidence.

Grace studied acting from 1948 to 1949 at the American Academy of Dramatic Arts in New York City, where she worked with well-known teachers including Konstantin Stanislavski and Lee Strasberg. She gained a solid foundation in acting techniques from their instruction and advice, which benefited her throughout her career.

Along with her instructors at the American Academy of Dramatic Arts and the Academy of the Holy Child, Grace also got the chance to work with several significant mentors in the entertainment business. She had one of her first parts in the 1957 movie "12 Angry Men" from famed director Sidney Lumet, who served as one of her mentors. She was able to grow as a professional actor and be ready for the obstacles she would encounter in the film business thanks to Lumet's advice and mentoring.

Alfred Hitchcock, a well-known filmmaker, was another significant mentor in Grace's life. He put her in a number of his films, including "Rear Window" (1954) and "To

Catch a Thief" (1955). She flourished as a professional actor under Hitchcock's tutelage and supervision, which also equipped her for the difficulties of collaborating with one of the greatest cinema directors of all time.

It is impossible to overestimate the influence these educators and mentors had on Grace Kelly's growth as a student and artist. They gave her the tools and information she needed to thrive in school and the entertainment business, helping to mold her drive and self-assurance.

In summary, Grace Kelly's intellectual and creative growth was greatly influenced by the mentors and professors who shaped her. Throughout her life, she was influenced by several significant mentors in the entertainment business, from her early schooling at the Academy of the Holy Child to her studies at the American Academy of Dramatic Arts. These people le helped her develop her ambition and confidence.

CHAPTER 3

Grace Kelly's Marital Life

Falling in Love and Meeting Prince Rainier

Grace Kelly and Prince Rainier

Grace Kelly's life was irrevocably altered in 1955 in the Palace of Monaco when she met Prince Rainier III of Monaco. The 45-year-old prince was looking for a suitable bride to assist him in modernizing and securing his nation's future. At the height of her career, Kelly, who was 25 years old at the time, was a well-known

Hollywood actress who exudes charm, beauty, and elegance.

At a dinner party thrown by Kelly's buddy Gene Kelly and the prince's sister Princess Charlotte, the two initially got together. Both the actress and the prince fell in love at first sight. Even though they were uncomfortable at first, they ended up talking for hours about everything from politics to art.

There were difficulties during their courtship. Rainier was a Catholic from Monaco, and Kelly was a Catholic from Philadelphia. The two had to negotiate the nuances of their customs and civilizations. Rainier had to pick up American ideals and conventions, while Kelly had to become used to the formality of royal life.

The language barrier was one of their main obstacles. Rainier spoke little English and Kelly less French. To speak with one another, they needed translators and interpreters. They still saw one other often despite these difficulties, and their bond became stronger.

At first, Kelly's relatives and acquaintances weren't sure about her connection with the prince. They were concerned about the possible hazards of marrying a foreign prince as well as the cultural differences. Kelly, nevertheless, was adamant about making things work, and her passion and commitment won her family over.

On June 6, 1956, at a private supper at the Palace of Monaco, Rainier proposed to Kelly. After Kelly said yes, they made their engagement public. The two started preparing for their April 19, 1956, wedding.

Celebrities and dignitaries from all around the globe attended the lavish wedding. Rainier donned his full military uniform, while Kelly looked gorgeous in a stunning white wedding gown made by Helen Rose. The ceremony was held in both French and English, with Cecil Beaton, Kelly's closest friend, acting as an interpreter.

Following their nuptials, Kelly assumed the title of Princess of Monaco, serving as Rainier's consort. She acclimated to royal life swiftly and was active in several cultural and charity endeavors. She became an advocate for the principality and picked up fluency in French.

In summary, Grace Kelly's encounter with Prince Rainier III of Monaco signaled the start of a dreamlike affair that would permanently alter her course in life. They had a difficult time communicating throughout their romance due to linguistic and cultural hurdles, but they eventually fell in love and started a life together as royalty.

The Royal Matrimony and Union

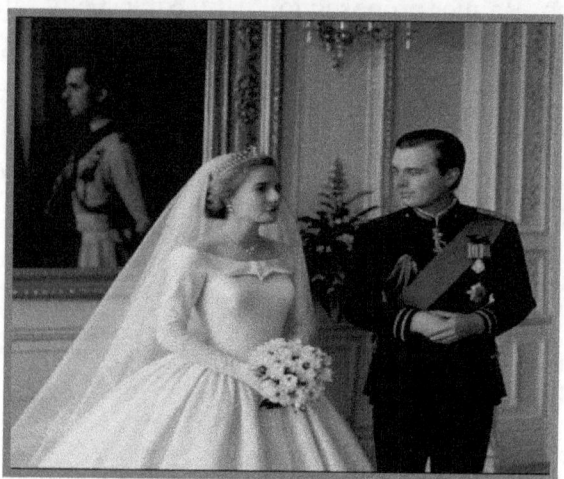

Grace Kelly and Prince Rainier on their wedding day

Princess Grace Kelly of Monaco wed Prince Rainier III in a sumptuous wedding at the Sainte-Dévote Church in Monaco on April 19, 1956. President John F. Kennedy, Queen Elizabeth II, and King Paul of Greece were among the dignitaries and royalty that attended the lavish wedding.

The chapel was decorated with thousands of flowers, candles, and candelabras, demonstrating the enormity of the wedding preparation project. The bride wore a gorgeous white gown with a delicate veil and a 10-foot train, made by Helen Rose. The groom, who served in

the French Navy before becoming Prince of Monaco, was dressed in uniform.

The Archbishop of Monaco officiated the wedding, while Prince Rainier's cousin Prince Louis II was the best man. In a customary Catholic rite, the newlyweds exchanged vows and the Archbishop pronounced them "husband and wife."

The lavish feast and lively dancing took place in the Palace of Monaco, the location of the reception. The Monte Carlo Philharmonic Orchestra performed "O Sole Mio," the tune that the couple danced to for the first time.

Following their nuptials, Princess Grace and Prince Rainier visited France and Italy as part of their honeymoon. Their days were spent going to cultural events and seeing the countryside.

However, marrying a king has its own set of difficulties and adaptations. This required Princess Grace to acclimate to a new nation, language, and way of life. The official language of Monaco was French, which she struggled to master, and she often felt alone and alone.

Along with difficulties, Prince Rainier was a new spouse. It was often hard for him to be true to himself because of his wife's Hollywood upbringing and celebrity. The duties of a monarch, including overseeing

state matters and reaching tough judgments, were another burden he had to bear.

The pair persevered in their commitment to one another and put a lot of effort into forging a solid marriage despite these obstacles. Their mutual appreciation of music, art, and culture served to strengthen their bond. Additionally, they encouraged each other's passions: Prince Rainier pursued his interests in environmental protection, while Princess Grace kept up her menial acting career.

Princess Grace and Prince Rainier had numerous difficulties during their early marriage, yet they never wavered in their dedication to one another. Three happy children, Caroline, Albert, and Stephanie, entered their lives.

In summary, Prince Rainier and Princess Grace's royal wedding was a lavish event that signaled the start of a new chapter in their lives. Despite the many obstacles they had to overcome in their early married life, they never wavered in their commitment to one another and made a concerted effort to create a solid and loving alliance.

Motherhood and Raising Children in the Royal Family

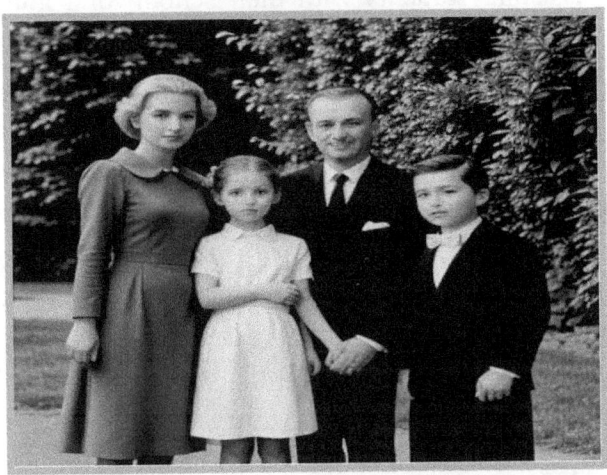

Princess Grace Kelly, Prince Rainier and their Children (Caroline and Albert)

At the age of 25, Princess Grace Kelly became a princess of Monaco when she gave birth to her first child, Princess Caroline, in 1957. She had to juggle her new job as a mother with her regal responsibilities as a member of the family. She had to balance being there for her child's early years with navigating the complexity of royal etiquette, so this was not an easy feat.

Despite the difficulties, Princess Grace embraced the pleasures and obligations of parenting and immersed herself in her new job. She made sure that Caroline and Albert, her two children, had a caring and loving

upbringing since she was committed to them. She was well-known for her hands-on attitude, often spending time assisting students with their schoolwork, going to school functions, and participating in extracurricular activities.

Being a royal family mother presented special difficulties for Princess Grace. She had to balance the demands of royal etiquette with making sure her kids enjoyed a typical childhood. She had to strike a balance between her responsibilities as a princess and the obligations of motherhood, all the while giving her kids a feeling of security and consistency.

Keeping her sense of self and identity intact was one of her toughest obstacles. Princess Grace was used to the limelight as a Hollywood actress, but she had to adjust to a more reserved position as a royal family mother. Her children and spouse, Prince Rainier, provided her with a sense of purpose and connection, and she took comfort in their connections.

Her parenting was not without its pleasures and chances, despite these difficulties. By bringing her kids to galleries and museums, she was able to share with them her passion for art and culture. She also fostered in them a feeling of social duty and supported their philanthropic activities, which stoked their passion for philanthropy.

Princess Grace remained involved in her children's lives as they got older. She assisted with their schoolwork and attended parent-teacher conferences as part of her involvement in their schooling. She encouraged them to participate in extracurricular activities by going to concerts and sporting events.

Princess Grace had to balance giving her daughter the freedom to make her own decisions and negotiating the difficulties of royal etiquette when Princess Caroline started dating. By striking a balance between providing support and establishing limits, she made sure her daughter realized how important it was to follow royal tradition but still have her autonomy.

Conclusively, Princess Grace's experience as a royal family mother was characterized by both chances and difficulties. She had particular difficulties juggling her motherly responsibilities with her royal responsibilities, but she also found happiness and purpose in being able to impart her ideals and interests to her offspring. Her legacy will serve as a reminder of the value of love, family, and public duty to both royal and non-royal generations in the future.

CHAPTER 4

Rise to Stardom

Her Career in Early Modeling and Pioneering Role

Grace Kelly started her modeling career as a youngster in Philadelphia after being found by Louise Dahl-Wolfe, a local photographer. Kelly's distinctive features were noticed by Dahl-Wolfe, a well-known Vogue magazine contributor, who urged her to pursue a modeling career. Kelly began her modeling career with a plethora of catwalk events and fashion magazine appearances. Her composure and elegance rapidly won her reputation.

Kelly's early modeling career consisted of a few minor jobs and regional fashion events. She gained expertise and confidence by modeling for several Philadelphia department stores and small shops. Kelly was sent to New York City in 1949 to take part in the Fashion Show of the National Cotton Council, where she attracted the interest of several well-known photographers and fashion designers.

Kelly relocated to New York City in 1950 to focus on her modeling profession full-time. She was swiftly contracted to work on high-profile fashion shoots and

ads by the esteemed modeling agency, John Robert Powers. Kelly's modeling career carried her to the Paris and New York runways, where her dazzling features and carefree manner won her recognition.

She was given the opportunity to try out for the psychological thriller "Fourteen Hours," which starred Robert Keith and Marlen Dietrich, in 1951. After a successful audition, Kelly was cast as Barbara Belney, a young lady caught up in a complex love triangle.

"Fourteen Hours" was a pivotal moment in Kelly's professional life. Kelly received broad acclaim as a young actress for the picture, which was a critical and financial triumph. Both reviewers and viewers praised her portrayal of Barbara Belney, with many highlighting her innate charm and nuanced emotional range.

Kelly portrayed a sophisticated and multifaceted character in "Fourteen Hours," negotiating the difficulties of relationships and love. Her performance was a considerable change from her previous modeling work, showcasing her abilities to communicate emotion and depth on film.

Kelly's career took a significant shift when "Fourteen Hours" became a hit, making her a rising celebrity in Hollywood. Due to the movie's popularity, Kelly was

cast in several well-known movies, such as "High Noon" (1952) and "Dark Passage" (1950). But her breakthrough performance in "Rear Window" (1954) solidified her place in Hollywood history.

To sum up, Grace Kelly's early modeling job served as a springboard for her acting career. Her breakthrough performance in "Fourteen Hours" signaled a major career turning point and brought her acclaim as a budding actor. "Fourteen Hours" helped Kelly become a Hollywood celebrity and cemented her place in history as one of the greatest actors of all time.

Kelly gained the expertise and exposure she needed from her early modeling career to successfully segue into acting. Her breakthrough performance in "Fourteen Hours" demonstrated her depth and ability to emote on film, solidifying her reputation as a gifted young actor. Kelly's career took a significant turn when "Fourteen Hours" became a hit; this led to a string of well-known movie roles and solidified her place as one of Hollywood's most adored actors.

The Academy Awards of 1955 and Princess Grace's Best Actress Nomination

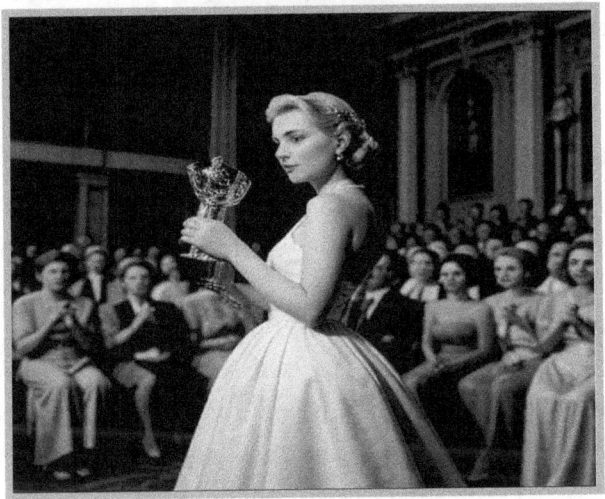

Grace Kelly while receiving Academy Award

Princess Grace Kelly had great joy at the 1955 Academy Awards, which were presented on March 30, 1955, at the RKO Pantages Theatre in Los Angeles, California. She was nominated for Best Actress for her performance in "The Country Girl." There was a tangible sense of excitement and expectation before the event, with both fans and members of the business anxious to see what would happen.

The crowd erupted in cheers as Princess Grace's name was revealed as the Best Actress winner and the envelope was opened. As she made her approach to the platform, Princess Grace, who is often calm and collected, was overcome with emotion, her eyes welling up with tears. Prince Rainier III, her spouse, and "The Country Girl" co-star Bing Crosby, who was also nominated for the part, joined her.

Princess Grace gave a moving and modest statement as she took the Oscar, expressing her gratitude to the Academy, her family, and her coworkers for this amazing achievement. She discussed the film's subject of redemption and the value of forgiveness, her voice shaking with emotion. She was greeted with raucous cheers that solidified her reputation as a Hollywood celebrity.

Princess Grace's career underwent a dramatic shift after winning the Academy Award, solidifying her place in the spotlight. Her portrayal of "The Country Girl" demonstrated her extraordinary versatility as an actress, and her victory cemented her place among the most gifted actors of her period.

Her personal life was significantly impacted by this honor as well. Now known as the Princess of Monaco, she was regarded as a symbol of refinement and

elegance in addition to being a gifted actor. Her spouse, Prince Rainier III, took great pride in her accomplishment, which strengthened their marriage.

Princess Grace's career took a dramatic swing after she won the Academy Award, moving from her previous femme fatale roles to more sophisticated and nuanced ones. Her later roles in movies like "High Society" and "Rear Window" demonstrated her brilliance and adaptability.

Princess Grace was commended by peers and colleagues for her skill and influence in the industry:
- "She was a true star... She had a presence on screen that was unmatched." - Bing Crosby, Jr.

- "Princess Grace was a natural actress... She had a gift for bringing depth and nuance to every role." - Audrey Hepburn's biography

- "She was a true Hollywood legend... Her talent and beauty left an indelible mark on our industry." - Gregory Peck.

Princess Grace Kelly had a sea change in her career and solidified her place in Hollywood history at the 1955 Academy Awards. Her emotional response to receiving the prize revealed her thankfulness and humility, and her

later roles highlighted her acting prowess and ongoing development. This honor is significant not only for her career but also because it shows how Princess Grace Kelly's influence on the film industry has endured.

Iconic Roles and Star Power

Grace Kelly in Fourteen Hours

Grace Kelly's breakout performance in "Fourteen Hours" (1951) cemented her status as a rising star in the film industry. Her following roles in movies such as "Rear Window" (1954) and "The Country Girl" (1954) solidified her reputation as a gifted and adaptable actor. Kelly portrayed Georgie Elgin in "The Country Girl," a stunning and endearing character who gets caught up in a convoluted love triangle.

Kelly's subsequent motion picture, "To Catch a Thief" (1955), was a significant shift from her previous parts. Kelly and Cary Grant appeared in the romantic thriller, directed by Alfred Hitchcock. Kelly's career underwent a dramatic shift when the movie became a hit, making her a Hollywood leading woman. Her portrayal of the elegant and refined thief Frances Stevens demonstrated her ability to project poise and grace on television.

Frank Sinatra and Bing Crosby co-starred with Kelly in the musical comedy "High Society," which was released in 1956. The movie was a huge hit, and Kelly received a lot of praise from critics for her portrayal of the gorgeous and endearing socialite Tracy Samantha Lord. Kelly's reputation as a Hollywood star was cemented when the movie's soundtrack, which included well-known songs like "Who Wants to Be a Millionaire" and "You're Sensational," became a huge smash.

Kelly was renowned for her grace, composure, and on-screen persona throughout her career. Her timeless beauty and elegant demeanor made her an ideal choice for the glamorous parts she often performed in. Her roles in movies like "To Catch a Thief" and "High Society" demonstrated her ability to exude charm and refinement, making her one of the greatest actresses of all time.

Kelly had unparalleled celebrity power while she was in Hollywood. She was often referred to as the "Queen of Hollywood" because of her exceptional beauty and brilliance. She became a worldwide icon and one of the most well-known and adored actresses of all time afterPpher 1956 marriage to Prince Rainier III of Monaco. Kelly continued to be a legendary figure in Hollywood even after she gave up acting, representing the elegance and glitz of the Golden Age of Hollywood.

How Alfred Hitchcock Affected Her Career

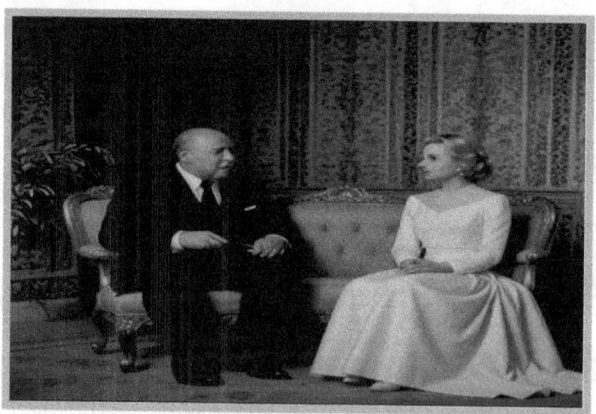

Grace Kelly and Alfred Hitchcock

An important turning point in Grace Kelly's career was when Alfred Hitchcock realized she had potential. Kelly

caught the notice of a famous director who was recognized for his ability to bring out the best in his performers and for paying close attention to detail. Her effortless grace, charisma, and on-screen persona won him over and he thought her distinct style would be a wonderful match for his style of filmmaking.

She featured with Ray Milland and Robert Cummings in Hitchcock's psychological thriller "Dial M for Murder," which was released in 1954. Kelly received praise from critics for her portrayal of Margot Wendice, a beautiful and endearing wife who is suspected of murder, and the movie was a huge hit. Kelly's performance, along with Hitchcock's directing, produced a picture that demonstrated her capacity to evoke both elegance and vulnerability.

Kelly's subsequent film project with Hitchcock was the romantic thriller "To Catch a Thief" (1955), in which Cary Grant co-starred. The movie was a huge hit, and Kelly's portrayal of the elegant and attractive thief Frances Stevens solidified her place among Hollywood's leading ladies. Kelly's ability to express charm and humor was on full display in this exciting and romantic picture, which was directed by Hitchcock and featured Grant's chemistry.

One cannot emphasize how important Hitchcock's partnerships with Kelly were. Her collaboration with the filmmaker shaped her character and reputation in the movies, making her known as a gifted and adaptable actor. Kelly's career was influenced by Hitchcock in several ways. First of all, he encouraged her to push herself to perform at new levels of complexity and depth, which helped her hone her acting abilities. Second, he made her more well-known and gave the world a chance to see her abilities.

Kelly's style and appearance were greatly influenced by Hitchcock and Kelly's collaborations. Her roles in the films "Dial M for Murder" and "To Catch a Thief" highlighted her timeless beauty and elegant demeanor, solidifying her status as a Hollywood glamor legend. Kelly's wardrobe choices, both on and off-screen, reflect Hitchcock's impact on her look. Hitchcock's love of vintage movies and his admiration of feminine charm had a big impact on her trademark sense of style, which featured chic hats and exquisite outfits.

The influence of Hitchcock and Kelly's work went beyond the screen. Her collaboration with the filmmaker contributed to her rise to fame in Hollywood and solidified her place among the greatest actors of all time. Her roles in the critically acclaimed movies "Dial M for Murder" and "To Catch a Thief" are still appreciated

today; in fact, many people consider them to be among the best movies ever made.

To sum up, Grace Kelly's career was significantly shaped by Alfred Hitchcock. His work with her shaped her cinematic identity and reputation, helped her become recognized as a gifted actor and improved her acting abilities. Their partnership had a lasting effect, as many people still consider Kelly to be one of the finest actresses of all time.

Partnerships and Collaborations with Co-Stars

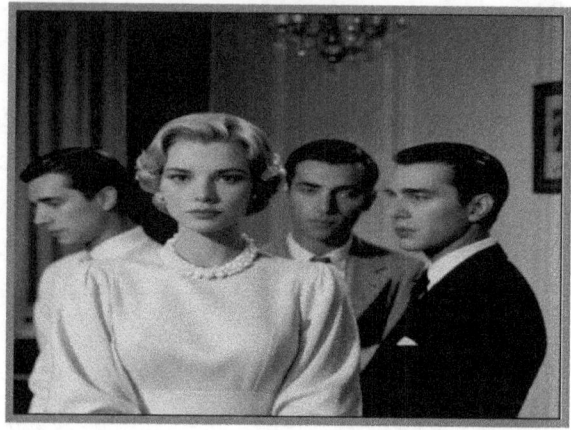

Grace Kelly, Cary Grant, James Stewart, and Bing Crosby

Grace Kelly was one of the most adored and renowned actresses of Hollywood's Golden Age, and her success was greatly influenced by the chemistry she had with her co-stars. She worked with some of the most gifted performers of her day on some of the most famous and enduring movies in movie history, creating lasting connections throughout her career.

Kelly worked with several big-name actors in her early Hollywood career, including Cary Grant, James Stewart, and Bing Crosby. Her on-screen interaction with James Stewart in Alfred Hitchcock's 1954 film "Rear Window"

was sensitive and heartfelt. This was her first significant part. The popularity of the movie might be ascribed to Kelly and Stewart's relationship, who portrayed a photographer and his model lover, respectively.

Kelly co-starred with Cary Grant in the 1955 film "To Catch a Thief," in which the two of them had a more playful and passionate on-screen relationship. The two played a cat-and-mouse game of cat theft, and a lot of the film's popularity came from their smart repartee and subtle appeal. There was no denying Kelly and Grant's connection, and their collaboration produced one of the most recognizable movies of the time.

A turning moment in Kelly's career was her partnership with Rock Hudson on "The Bridges at Toko-Ri" (1955). The compelling on-screen connection between Kelly and Hudson, who portrayed an American pilot and his wife during the Korean War, enhanced the film's dramatic and emotional plot. Their collaboration gave the movie depth and emotional impact and solidified Kelly's standing as a gifted dramatic performer.

Frank Sinatra, Louis Jourdan, and Bing Crosby co-starred with Kelly in the opulent musical version of Philip Barry's drama "The Philadelphia Story" in "High Society" (1956). The film's success was mostly attributed to the dazzling rapport between Sinatra's jazz

musician character and Kelly's affluent socialite persona. Their flirtatious banter and passionate duets contributed to the fun and carefree atmosphere of the movie.

One of Kelly's greatest professional moments was working with Fred Astaire on "Funny Face" (1957). The seamless synergy between Kelly and Astaire, who portrayed a fashion model and a photographer, respectively, enhanced the film's musical sequences and humorous appeal. Because of their endearing and naive on-screen relationship, the movie became a renowned classic of its time.

Kelly's love drama "The Swan" (1956), in which she co-starred with Louis Jourdan, demonstrated her breadth of emotions. The on-screen relationship between Kelly and Jourdan, who portrayed a royal princess and a prince, respectively, was a major factor in the popularity of the movie. Their collaboration gave the romance plot of the movie more depth and subtlety.

Kelly collaborated with some of the greatest performers of her day throughout her career, creating some of the most recognizable and memorable movies in movie history. She routinely gave remarkable performances that enthralled audiences all around the globe, and a major contributor to her popularity was her ability to develop great on-screen chemistry with her co-stars.

Grace Kelly's Role and the Impact of Technological Innovation on the Hollywood Industry

In addition to being a gifted performer and one of the most recognizable actresses of Hollywood's Golden Age, Grace Kelly was also a trailblazer in the film industry's adoption of technological innovation. Kelly collaborated with some of the most avant-garde directors of the day throughout her career, such as Alfred Hitchcock, who was renowned for his experimental use of narrative and filming methods.

One of the first technological innovations Kelly worked on in Hollywood was the use of CinemaScope, a widescreen format that 20th Century Fox debuted in 1953. One of the first movies to use CinemaScope was Stanley Kramer's 1955 picture "The Rains Came" starring Kelly. The film's use of cutting-edge technology made for a more visually spectacular and immersive cinematic experience, elevating Kelly's performance and solidifying her place in the leading lady category.

The creation of stereophonic sound is a noteworthy technical advancement that Kelly contributed to. One of the earliest movies to use stereophonic sound was "The Country Girl," starring Kelly, released in 1954. The employment of this cutting-edge technology in the

movie made for a more immersive and realistic auditory experience, which heightened the emotional impact and dramatic tension of the picture.

Kelly and Alfred Hitchcock's 1954 film "Rear Window" together represented yet another important turning point in Hollywood's use of cutting-edge technology. Hitchcock was well-known for his experimental approach to cinema, and his use of cutting-edge special effects and camera work contributed to an unusual level of suspense and realism during the period. Hitchcock's use of avant-garde camera methods further accentuated Kelly's performance in the movie, which demonstrated her capacity to portray emotion and vulnerability on screen.

Kelly collaborated with filmmaker Alfred Hitchcock once again for "To Catch a Thief" (1955), using more sophisticated filming methods such as handheld cameras and Steadicam shots to provide a more dynamic and realistic visual aesthetic. The employment of these new technologies in the movie increased the flexibility and mobility of the scenes' shooting, which raised the intensity and thrill of the movie.

Kelly's contribution to television's advancement also had a big impact on the Hollywood business overall and on her career. As television gained popularity in the early

1950s, many performers and actresses wanted to make the switch from cinema to television. Kelly's TV appearances on series like "What's My Line?" and "The Ed Sullivan Show" contributed to her reputation as a flexible actress who could work in a variety of settings.

Grace Kelly's participation in technological advancement throughout her Hollywood career greatly influenced both her profession and the industry at large. Her eagerness to try new things and her partnerships with avant-garde directors like Alfred Hitchcock elevated her performances and solidified her place as one of the most recognizable actresses of Hollywood's Golden Age.

The Impact of technology in Grace Kelly Career are:

Important Novelties:
1. The widescreen format known as CinemaScope was first launched by 20th Century Fox in 1953. Kelly used it for her picture "The Rains Came" (1955).
2. Stereophonic Sound: Kelly's 1954 picture "The Country Girl" took advantage of this new audio technology, which was first introduced in the early 1950s.
3. In "To Catch a Thief" (1955), Kelly used a handheld camera technique called "Steadicam Shots," which was created by Garrett Brown in the early 1960s.

4. With her picture "To Catch a Thief" (1955), Kelly used handheld cameras, a novel camera method that provided her more flexibility and movement.

The impact on Hollywood:

1. Improved Visual Style: A more realistic and engrossing visual style was produced with the use of creative camera methods and special effects.
2. Enhanced Realism: A more immersive and realistic audio experience was made possible by the use of stereophonic sound and other audio technology.
3. Enhanced Versatility: Kelly's versatility as a performer was partly attributed to her capacity to adapt to many forms and media, including television.
4. New Career Opportunities: Actors and actresses were able to go from cinema to television thanks to the growth of the television industry.

History:

1. Renowned Status: Kelly's contributions to technological advancement have solidified her standing as one of the most recognizable actors from Hollywood's heyday.
2. Kelly's openness to experimenting with new technology served as an inspiration for other actors and actresses to follow suit.

3. Impact on Upcoming Directors: Kelly's work on movies like "Rear Window" (1954) and "To Catch a Thief" (1955) had an impact on upcoming directors like Francis Ford Coppola and Martin Scorsese.

4. Timeless Appeal: Kelly's films are still praised today for their avant-garde narratives and cinematography styles, which have contributed to their status as timeless masterpieces.

Grace Kelly's Impact on Fashion Trends

Grace Kelly became one of the most famous fashion icons of her day because of her impeccable sense of style and sense of fashion, which enthralled viewers all over the globe. Generations of fashion specialists, designers, and stylists have been inspired by her ageless elegance, exquisite taste, and easy charm. Kelly's popularity of the "elegance is next to godliness" philosophy—which prioritizes quality, longevity, and simplicity above fads—indicates her effect on fashion.

Famous couturiers including Edith Head and Orry-Kelly created Kelly's famous dresses, which have remained a mainstay of fashion history. Kelly's magnificent Head-designed gown from her 1954 Hollywood debut in "The Country Girl" served as the model for her future

red carpet appearances. Kelly's personality and style were reflected in the dresses, which were generally distinguished by their subtle beauty, refinement, and simplicity. These famous gowns have become part of fashion history's most recognizable items because of their immortalization in movies, pictures, and exhibits.

Kelly's continued impact on fashion is partly responsible for the 1980s and 1990s emergence of vintage fashion. Kelly's dresses became a mainstay of vintage fashion collections as fashion fans started to recognize the beauty of traditional designs. Designers like Christian Lacroix and Jean Paul Gaultier have recreated and reworked Kelly's famous gowns, taking cues from her timeless elegance and classic designs. The work of modern designers like Oscar de la Renta and Valentino, who have infused aspects of old glamor into their creations, is also influenced by Kelly's dresses.

Kelly has impacted the fashion business more broadly than only her renowned outfits. A generation of designers that value quality over quantity, simplicity over complication, and enduring elegance over fads have been influenced by her subtle but elegant approach to fashion. The "capsule wardrobe" concept, which stresses assembling a wardrobe around a few key items rather than continuously purchasing new trends, is another example of her impact.

Kelly's legacy has been felt not just in the direct impact she had on fashion design but also in the way contemporary society has appropriated and reinvented her. Her reputation as a timeless cultural icon has been cemented by celebrating her distinctive style in movies, music videos, and runway displays. Kelly's ability to transcend decades and her lasting appeal is shown by her constant fascination with her style.

In conclusion, Grace Kelly's iconic dresses, classic elegance, and modest but sophisticated attitude to fashion have left a lasting impression on fashion trends. Her legacy has served as an inspiration to many designers, stylists, and fashion fans, solidifying her place among the greatest fashion icons of all time. Kelly's style is a tribute to her lasting appeal as it never fails to wow audiences worldwide and inspire new generations to see the beauty of traditional elegance and fashion.

The Sad Demise: Car Accident and Legacy

Princess Grace Kelly's life changed drastically on May 19, 1955, when she was involved in a terrible vehicle accident on the French Riviera. The accident was caused by a confluence of unfavorable weather, careless driving, and unfortunate events. Kelly was cruising the narrow streets of the Corniche between Monaco and Nice in her husband's 1955 Mercedes-Benz 300SL convertible. The rain had made the road slippery, and Kelly was traveling quickly when she lost control of the car. The vehicle veered off the path, colliding with a stone barrier before toppling over.

Kelly was severely injured, breaking her collarbone, breaking her shoulder blade, and injuring her face severely. Prince Rainier III, her spouse, sustained injuries in the collision as well. After being taken to the hospital quickly, the couple was given medical attention. The mishap significantly affected Kelly's professional and personal lives. After being compelled to take a vacation from acting, she ultimately decided to permanently quit Hollywood. Her choice to concentrate on her royal responsibilities was strengthened by the accident since she had always been dedicated to her job as Princess of Monaco.

Kelly's Hollywood career, which had been characterized by both critical and financial success, came to an end when she chose to quit acting. Even though she had grown to be one of the most adored and esteemed actors of her day, she was aware that her royal duties would always come first. Kelly had a lasting impact in Hollywood, even if she left too soon. Her timeless elegance and style continue to influence a great number of fashion designers and lovers, leaving a lasting legacy in the fashion world.

Kelly is still honored in popular culture because of her classic movies, including "High Society," "To Catch a Thief," and "Rear Window." Her comedic, charming, and sophisticated performances are still highly praised. Beyond her work in movies, Kelly left a lasting impression on the world as one of Monaco's top travel destinations. She used her royal platform to raise money and awareness for many philanthropic projects, working diligently to promote the nation's natural beauty and rich cultural heritage.

Many fashion designers pay tribute to Kelly's signature style, and her legacy continues to inspire others. Generations of fashion fans have been affected by her love of traditional American sportswear and European high couture. There is no denying her impact on fashion;

several designers have acknowledged her as an inspiration for their creations. Kelly's ageless beauty and refinement are shown in a variety of fashion exhibits and retrospectives, which continue to commemorate her renowned style.

In summary, Princess Grace Kelly experienced both sorrow and success in her life. Her Hollywood career came to an end in 1955 when she was involved in an automobile accident, but her influence lives on thanks to her famous films, keen sense of style, and charitable endeavors.

CHAPTER 5

Humanitarian Work and Philanthropy

Backing for Women's Empowerment and Education

The former Hollywood actress and current Queen of Monaco, Princess Grace Kelly, was a fervent supporter of women's rights and education. She dedicated her life to promoting women's issues and endeavors, especially via the Princess Grace Foundation. The foundation was founded in 1957 to advance social welfare, culture, education, and women's empowerment.

Giving scholarships to women seeking higher education in the arts and sciences was one of the Princess Grace Foundation's main goals. The foundation understood that education was critical to women's empowerment and ability to make a positive contribution to their communities. The scholarships helped women pursue studies in the legal, medical, technical, and artistic domains financially.

Princess Grace has a strong commitment to the advancement of women's empowerment and education. She thought that for women to realize their full potential and have a constructive influence on society, education was an essential instrument. She was also aware of the obstacles that many women, especially in poorer nations, encountered while trying to get an education.

The Princess Grace Foundation funded several programs targeted at enhancing women's access to education to solve these issues. These efforts included funding programs that supported girls' education and attempted to lessen gender-based violence, as well as supplying educational materials and resources to communities and schools.

Princess Grace was not just active in the Princess Grace Foundation but also a strong supporter of women's rights and empowerment. She felt that women ought to be respected and treated with dignity and that they need to have equal access to chances for participation in all facets of society.

Princess Grace's personal life and experiences demonstrated her dedication to women's education and development. Being a successful professional herself, she understood the obstacles that many women had to overcome to reach their objectives. She supported efforts to address these issues and utilized her position to spread awareness of them.

Princess Grace has made significant contributions to women's education and empowerment, some of which are as follows:

- ❖ The Princess Grace Foundation's scholarship initiative, which supports women seeking advanced degrees in the humanities and sciences

- ❖ The foundation's backing of educational programs designed to increase women's access to higher education

- ❖ Princess Grace's activism for women's empowerment and rights

- ❖ Her participation in several philanthropic programs and organizations that promoted women's empowerment and education

Princess Grace Kelly's legacy is defined by her dedication to promoting women's empowerment and education. Through her work with the Princess Grace Foundation, she pushed for women's rights and empowerment, promoted access to education for women, and gave financial assistance to women seeking higher education in the arts and sciences. Future generations of

women leaders, researchers, and campaigners are still motivated by her legacy.

Charity Activities in Monaco and Other Locations

The former Hollywood actress and current Monarch of Monaco, Princess Grace Kelly, was a passionate supporter of women's education and empowerment. She never wavered in her dedication to supporting women's interests and endeavors, especially via the Princess Grace Foundation. The foundation was founded in 1957 to promote social welfare, education, and culture with an emphasis on women's empowerment. Some of the charitable works are:

Scholarships for Female Students Pursuing Advanced Degrees: Giving scholarships to women seeking higher education in the arts and sciences was one of the Princess Grace Foundation's main goals. The foundation understood that education was critical to helping women reach their full potential and contribute positively to society. These scholarships offered financial assistance to female students pursuing degrees in the legal, medical, engineering, and artistic domains.

Empowering Women with Knowledge: Princess Grace thought that a key component of women's emancipation was education. She saw that education might assist women in breaking through social and cultural obstacles, becoming independent, and creating their own identities. She wanted to provide women access to opportunities, resources, and knowledge that would help them achieve via her foundation.

Encouraging Women's Empowerment and Education: *The Princess Grace Foundation sponsored several programs designed to increase women's access to higher education. Among these efforts were:*

- Providing communities and schools with educational materials and resources

- Endorsing initiatives that decreased gender-based violence and advanced girls' education

- Providing grants and scholarships to female students seeking advanced degrees in the arts and sciences

Soliciting the Empowerment and Rights of Women: Princess Grace was a strong supporter of women's empowerment and rights. She felt that women

ought to be respected and treated with dignity and that they need to have equal access to chances for participation in all facets of society. She made use of her position to advocate for programs that assisted women's empowerment and to increase public awareness of the difficulties that women confront.

Prominent Instances of Princess Grace's Work: *Princess Grace has made significant contributions to women's education and empowerment, some of which are as follows:*

- ★ **The Princess Grace Foundation Scholarship:** Women seeking postsecondary study in the arts and sciences were eligible for scholarships from the foundation.

- ★ **The Princess Grace Foundation's Educational Initiatives:** The foundation provided funding for several programs designed to increase women's access to higher education.

- ★ **The Princess Grace Foundation's Support for Women's Empowerment:** The foundation gave money to groups that supported gender equality and women's empowerment.

★ **Princess Grace's Advocacy Work:** Princess Grace took advantage of her position to advocate for women's empowerment and education.

Princess Grace Kelly's dedication to promoting women's empowerment and education has defined her legacy. Through her work with the Princess Grace Foundation, she pushed for women's rights and empowerment, promoted access to education for women, and gave financial assistance to women seeking higher education in the arts and sciences. Future generations of women leaders, researchers, and campaigners are still motivated by her legacy.

Tradition of Giving Away

Grace Kelly was well-known for her generosity and dedication to giving back to her community over her whole life. She carried on this tradition as Princess of Monaco by using her position to promote other nonprofits and causes. Her influence on the field of charity is evident, and her legacy of giving back is still honored today.

Working with the Monegasque Red Cross was one of Kelly's most important philanthropic projects. She often attended fundraising events and took part in charity

auctions as a devoted supporter of the organization. Her participation aided in the fundraising of money and exposure for the organization's many projects, which included humanitarian assistance and disaster relief.

Kelly was a fervent supporter of initiatives related to children as well. She visited ill children and made donations to the hospital's many programs to show her support for the Monegasque Children's Hospital. Her own son, Albert II, the current ruler of Monaco, was not the only kid she loved. She was a loving grandma and mother who prioritized her family's needs above anything else.

Kelly was active in global humanitarian endeavors in addition to her work with regional groups. She supported the efforts of the United Nations Children's Fund (UNICEF) to enhance the lives of children everywhere by becoming a patron of the organization. She also collaborated with other groups, including Save the Children, to aid those impacted by armed conflicts and natural catastrophes.

Kelly's dedication to charity extended beyond her formal responsibilities as the Princess of Monaco. She often gave money to charities that were near and dear to her heart as a kind contributor to a wide range of philanthropic projects. She became an inspiration for

charity in Monaco, and her selflessness encouraged others to follow in her footsteps.

Kelly founded the Princess Grace Foundation, one of her most well-known charitable projects. The foundation was established in 1962 to assist burgeoning performers and artists in their careers. The charity helped gifted people reach their objectives by offering grants and scholarships. Kelly left a long legacy with this organization because of her passion for the arts and her desire to develop new talent.

Kelly passed away in 1982, but her impact lived on, encouraging others to give back to their communities. The Princess Grace Foundation is still going strong and helps performers and artists all around the globe. Albert II, her son, has likewise continued his mother's charity work by contributing to several nonprofits and causes.

Grace Kelly's legacy of giving back is evidence of her compassion, magnanimity, and dedication to changing the world for the better. Her charitable endeavors serve as a source of inspiration for others, and future generations will remember her legacy.

CHAPTER 6

Lessons Learned

Survival and Adaptability in the Face of Difficulties

Despite her reputation for composure and grace, Princess Grace of Monaco was not immune to life's trials. Even though she had a luxurious life as a Hollywood actress and member of the nobility, she encountered many challenges that put her fortitude and resilience to the test. Princess Grace had several obstacles in her life, including personal hardships, health problems, and negative media coverage, but she overcame them by seeing them as chances for personal development.

Princess Grace's battles with epilepsy were among her worst medical problems. After receiving a diagnosis in her early twenties, she concealed the illness out of concern for how it might impact her career. She persisted in acting despite this, ultimately rising to become one of the most adored performers of her day. Her courage in dealing with this medical condition was evidence of her tenacity.

She had a lot of personal hardships in the 1960s. She was managing the difficulties of marriage and motherhood in addition to getting used to her new position as Princess of Monaco. She was left to raise their son, Albert II, alone since her husband, Prince Rainier III, was often gone on official business. Her physical and mental health suffered as a result of these conditions, and she had spells of worry and sadness.

However, she persisted in the face of these obstacles. She devoted herself to her royal responsibilities and used her position to promote philanthropic causes and institutions. Her resolve to change the world and her devotion to her role as a princess served as a diversion from her hardships.

Her life was significantly impacted by the media as well. As a member of the royal family and a Hollywood celebrity, she was often watched. The media often attacked her appearance, demeanor, and alleged lack of participation in royal tasks. Her confidence and self-esteem suffered as a result of these critiques, but she resisted allowing them to define who she was.

Princess Grace responded to the criticism by concentrating on her acts and conduct, which she could control. She carried on attending royal gatherings and events with elegance and poise, never losing her cheerful

disposition. She also supported issues near to her heart, such as education programs and charity for children, by using her platform.

Moreover, she has several difficulties in her life that put her fortitude and resilience to the test. She never let these challenges stop her, however. Rather, she saw them as chances for development and betterment of herself.

In addition, Princess Grace left behind a legacy of bravery, tenacity, and resilience in the end. We are all inspired by her capacity to persevere in the face of difficulty and overcome misfortune. Her desire to make the most of every opportunity is a monument to her perseverance and an example to anybody facing their struggles. As she recently said, "I have been very fortunate in my life. I have had the chance to do many things that I wanted to do."

To sum up, Princess Grace's tale serves as a potent reminder of the value of tenacity and fortitude in the face of difficulty. She overcame several health problems, went through personal hardships, and received negative press, yet she persisted in living a fulfilling life and changing the world. Her legacy serves as evidence of how the human spirit can persevere in the face of adversity and come out stronger on the other side.

Crucial Qualities: Genuineness, Lowliness, and Empathy

Princess Grace of Monaco—who was renowned for her grace, elegance, and kindness—embodied three essential qualities: humility, compassion, and sincerity. These qualities, which are often missed in the glitz and celebrity of her life, were crucial to forging close bonds with people and leaving a lasting impression on the globe.

A defining quality of Princess Grace's personality was her authenticity. She never attempted to live up to the expectations of others; she was unabashedly herself. Her commitment to humanitarian work and her true love of the arts never wavered, and she never let her morals be compromised to fulfill her royal duties. Her genuine nature engendered allegiance and confidence in those in her vicinity, and she was renowned for her aptitude for establishing profound and significant bonds with others.

A prominent illustration of Princess Grace's genuineness is her dedication to her offspring. Her royal responsibilities never eclipsed her position as a mother, and she was a loving mother to her son, Albert II, and daughter, Caroline. She spent endless hours telling tales, playing games, and just being with her kids because she really and unconditionally loved them.

Another important quality that characterized Princess Grace was her humility. She maintained her modesty and groundedness despite her royal rank and Hollywood stardom. She never allowed her status or notoriety to go to her head, choosing instead to utilize her influence to change the world for the better. Others were moved by her humility to see beyond her regal rank and see the real person below.

The Red Cross service Princess Grace does is one instance of her humility. She often attended fundraising events and took part in charity auctions as a devoted supporter of the organization. Her participation aided in the fundraising of money and exposure for the organization's many projects, which included humanitarian assistance and disaster relief. Her dedication to assisting people in need was shown by her humility in serving others without expecting praise or compensation.

Another vital quality Princess Grace had throughout her life was compassion. Whether it was a youngster in need or a struggling artist, she had a great sense of empathy for everyone around her. She was well-known for her capacity to unite people through acts of kindness, and her compassion motivated others to be more empathetic and compassionate as well.

Princess Grace's involvement with disabled children is one instance of her compassion. She often visited hospitals and rehabilitation facilities to spend time with the youngsters under her patronage, the Monegasque Association for the Protection of youngsters with Disabilities. She had a lasting impression on the lives of many youngsters with her compassion and generosity, which encouraged hope and pleasure in everyone around her.

People throughout the globe are still motivated by Princess Grace's genuineness, modesty, and compassion. Her experience serves as a reminder that real greatness comes from being sincere, kind-hearted, and dedicated to having a beneficial effect on the world—rather than from external approval or celebrity.

To sum up, Princess Grace's life served as an example of the strength of sincerity, modesty, and kindness. These characteristics, which to some may seem straightforward or even commonplace, are remarkable in their capacity to forge meaningful connections with others and spur constructive social change. When we consider Princess Grace's life, we are reminded that real greatness comes from being sincere, kind-hearted, and dedicated to changing the world—rather than from outward recognition or celebrity.

The Value of Self-Care, Community, and Family

Grace Kelly also known as Princess Grace has shown tremendous lessons in the following ways:

Household

- The foundation of Princess Grace's life was her close bonds with her family.

- She gave her everything to her spouse, Prince Rainier III, and their two children, Caroline and Albert II.

- She placed a high value on spending quality time with her family, often taking care of their needs and participating in activities with them.

- Her family provided her with comfort and support, and she treasured the time they shared.

Group

- Princess Grace had a strong devotion to her neighborhood and the people of Monaco.

- ❖ She supported several philanthropic endeavors and organizations while working nonstop to enhance the lives of her compatriots.

- ❖ She supported the growth of Monaco's cultural and artistic industries as a patron.

- ❖ She found inspiration and drive in her neighborhood, and she was appreciative of the chance to have a constructive influence.

Taking Care of Yourself

- ★ Despite stressful situations, Princess Grace's well-being depended on her ability to prioritize self-care.

- ★ She understood the need to look after her bodily and emotional needs.

- ★ She did things that made her happy, including swimming, gardening, and reading.

- ★ She also scheduled time for self-care and relaxation, engaging in yoga and meditation.

- ★ Her self-care regimen allowed her to be upbeat and energetic even in the face of difficult circumstances.

Most Important Lessons

➢ Princess Grace held the core principles of self-care, community, and family in high regard.

➢ Having solid ties with family members gave one a feeling of support and belonging.

➢ Her participation in the community enabled her to have a beneficial effect on the globe.

➢ Making self-care a priority allowed her to stay healthy despite stressful situations.

Princess Grace's life is a potent illustration of the value of self-care, community, and family. She was able to maintain her well-being in the face of adversity, forge solid bonds with her loved ones, and have a beneficial influence on her community by putting these principles first.

CONCLUSION

In Conclusion, the intriguing and little-known tale of Princess Grace Kelly's incredible ascent to fame is revealed in "The Hollywood Princess: The Inspirational Ideas Behind the Elegant Life of Grace Kelly. Kelly's biography, which begins with her modest debutante days in Philadelphia and ends with her ascent to fame in Hollywood, is a tribute to her brilliance, tenacity, and unshakable commitment to her work. Kelly had a lasting impression on the globe with her classic movies, sense of style, and charitable work. These things solidified her reputation as a beloved and enduring Hollywood figure.

www.ingramcontent.com/pod-product-compliance
Lightning Source LLC
Chambersburg PA
CBHW070121230526
45472CB00004B/1359